S0-ABR-725

HERB JACKSON
EXCAVATIONS

HERB JACKSON
EXCAVATIONS

Organized by Brad Thomas

Essay by Roger Manley

Van Every/Smith Galleries
Davidson College

Herb Jackson: Excavations
Publication © 2011 Davidson College
Essay © 2011 Roger Manley
Artist's images © Herb Jackson

Van Every/Smith Galleries
Davidson College
315 North Main Street
Davidson, NC 28035-7117

davidsoncollegeartgalleries.org

All rights reserved. Printed in the United States.
No part of this publication may be reproduced
or distributed in any form without the prior
written permission of the publisher.

ISBN: 978-1-890573-11-9

Herb Jackson: Excavations is made possible
through the generous support of Golden Artist Colors, Inc.,
New Berlin, NY, and is published in conjunction
with the exhibition of the same name featured at the
Van Every/Smith Galleries, Davidson College,
March 11–April 20, 2011.

Design: John Brooks Gray
Copyediting: Gerald Zeigerman
Photography: David Ramsey
Printing: Belk Printing Technologies, Pineville, NC

Front and back covers: *Veronica's Veil CXCVII* (detail), 2010,
Acrylic on canvas, 60 x 48 inches

CONTENTS

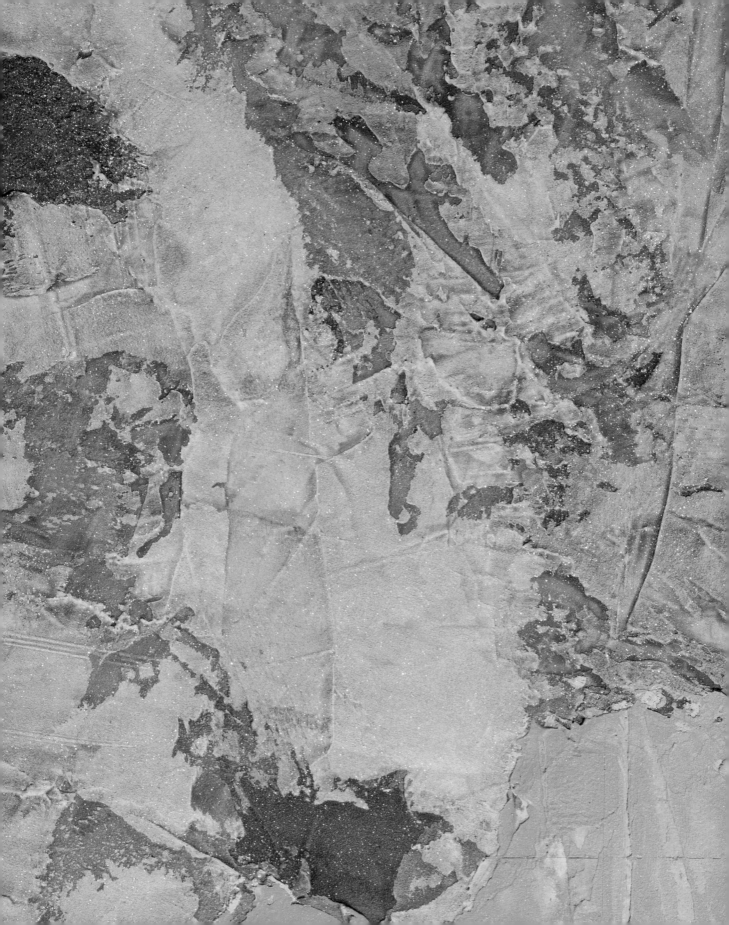

HERB JACKSON: EXCAVATIONS

Brad Thomas

In the beginner's mind there are many possibilities, but in the expert's there are few. —Shunryu Suzuki[1]

Many know and respect Herb Jackson as the accomplished painter of abstract works that have been the subject of more than one-hundred-fifty solo exhibitions in the United States and abroad. His paintings and works on paper are also included in more than eighty international art museum collections. Herb's artistic achievements have garnered him numerous awards of merit, including the North Carolina Award, the state's highest civilian honor. Credentials such as these might very well be enough to define a successful career in the arts, but it is also his work as a teacher, curator, philanthropist, and champion of emerging and underrecognized artists that distinguishes Herb Jackson as a true cultural leader.

For more than forty years, Herb has called the town of Davidson home. In his studio, just off Main Street, he continues to produce vibrant, enigmatic works with all the energy, conviction, and wonder of a budding young artist who is feeling the tug of paint against primed cotton duck for the very first time. He continually strives to expand the possibilities of color, texture, and composition in new and unexpected ways. Although he has developed an unmistakable signature style, his art remains not an act of refinement but of constant discovery.

In May 2003, I attended an artists' retreat at Camp Rockmont, in Black Mountain, North Carolina. Many know this as the site of the former Black Mountain College (1933–57), an innovative liberal arts school that produced some of the most influential creative talents of the twentieth century. It seemed only fitting that our diverse group of international artists, writers, curators, and musicians should gather on such hallowed ground for a week of information exchange and free-form collaboration.

On an overcast afternoon, I found myself on the porch of one of the residential lodges. The conversation—as it was—drifted in and out among those gathered in rocking chairs and along the railing. Multimedia artist Pinky Bass strummed a ukulele and intermittently read aloud poetry written by one of our colleagues. The ceramist and sage Clara "Kitty" Couch pinched out small organic forms in red clay. Herb quietly worked on large sheets of paper at a makeshift drawing table.

As I cut'n'pasted in one of my rather amorphous notebooks, I happened to notice in Herb's supply box a copy of *Zen Mind, Beginner's Mind*—a collection of transcribed informal talks on Zen practice by the late Buddhist teacher Shunryu Suzuki. I was very familiar with the book as I had carried and studied my own well-worn copy for some time; however, I did think it curious that someone as accomplished as Herb would be reading a book for "beginners."

Now, anyone familiar with the Buddhist path will appreciate that my immediate reaction to the juxtaposition reflected an improper attitude on my part. I had fallen into an age-old trap: I was assuming that we live in a world of absolutes—that achievement and a certain naive wonder are incompatible.

For Herb, each new day, each new canvas, each new mark offers the reward of discovery via the mystery of the unknown. It is his willingness to embrace mystery that allows the creative spirit to thrive in the moment by letting go of assumptions and recognizing the fallacy of absolutes. Here, Suzuki might add that "this is also the real secret of the arts: always be a beginner."[2]

Some years following that afternoon in Black Mountain, I asked Herb what *Zen Mind, Beginner's Mind* meant to him. He thought for a moment—as he always does when asked a question, whether trivial or profound—and offered that Suzuki's teachings provide a "confirmation of the importance of being lost." That answer called to mind something that Herb has said before: "My inner journey through art confirms, for me at least, that it is not necessary to rob life of its mystery in order to understand it."

The book you now hold in your hands celebrates Herb's fiftieth year as a professional artist. Although the works documented between its covers only scratch the surface of his ever-expanding body of work, it is

a testament to the discoveries made with each painting and how each, in turn, informs the next. Furthermore, Herb has dedicated forty-two of those fifty years to teaching students at Davidson College.

The personal and creative awareness that Herb has developed over the years allows him the freedom to trust his practice and respond to each new day, each new canvas, each new mark as a beginner. His ability to convey this attitude to his students—beginners in the truest sense—is his greatest gift.

In this book, Roger Manley '74 reflects on the profound influence that Herb had on him during his formative years at Davidson. He explains how Herb's dedication to teaching and art-making subsequently influenced his own career as a renowned photographer, author, curator, filmmaker, and folklorist. Similar reflections by former students about life paths altered and horizons expanded might very well fill volumes.

As Manley's story leads us through the strata of his own personal history to the occasion when a young art professor helped him unlock his inner neophyte, so, too, does the timeline of paintings that follows this introduction illustrate the story of Herb's creative journey through color, form, and texture. Beginning, in 1961, with the earthen tones and tactile grit of *Rock Strata* to the atmospheric framework of *Veronica's Veil* CC (2010), we discover that allusions to the wonders of the natural world remain the constant and buoyant force of Herb's explorations.

So, take your time. Begin at the beginning. Again.

Notes

1 Shunryu Suzuki, *Zen Mind, Beginner's Mind* (New York and Tokyo: Weatherhill, 1973), 21.

2 Ibid., 22.

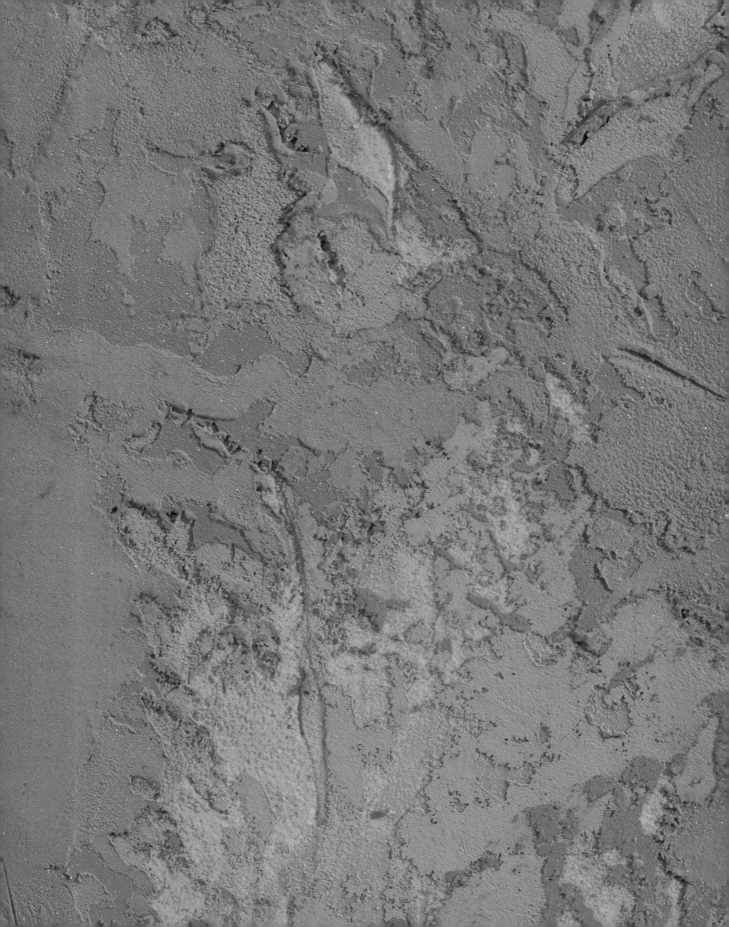

PLATES

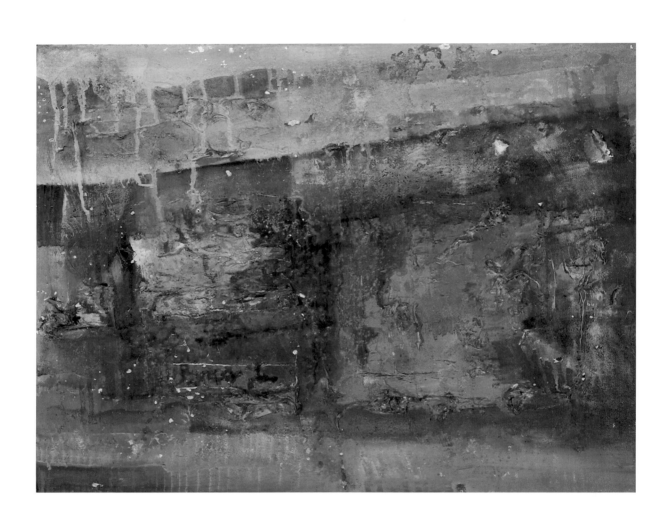

Rock Strata, 1961, Oil on canvas, 17 x 22 inches

1961

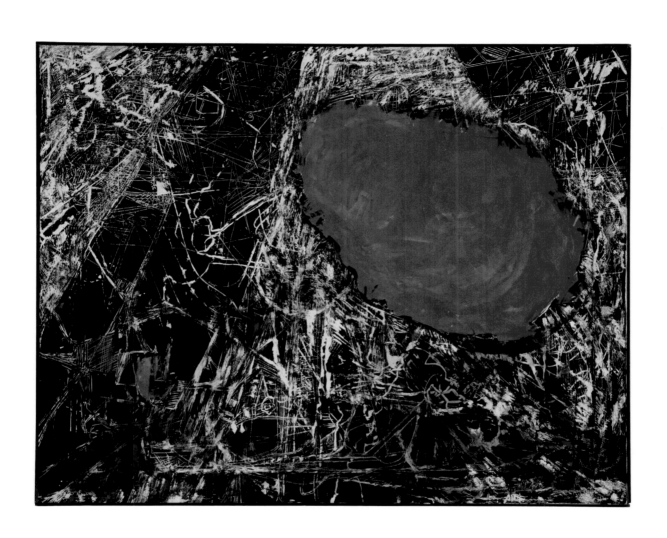

Night of the Owl's Eye, 1965, Oil on canvas, 48 x 60 inches

1965

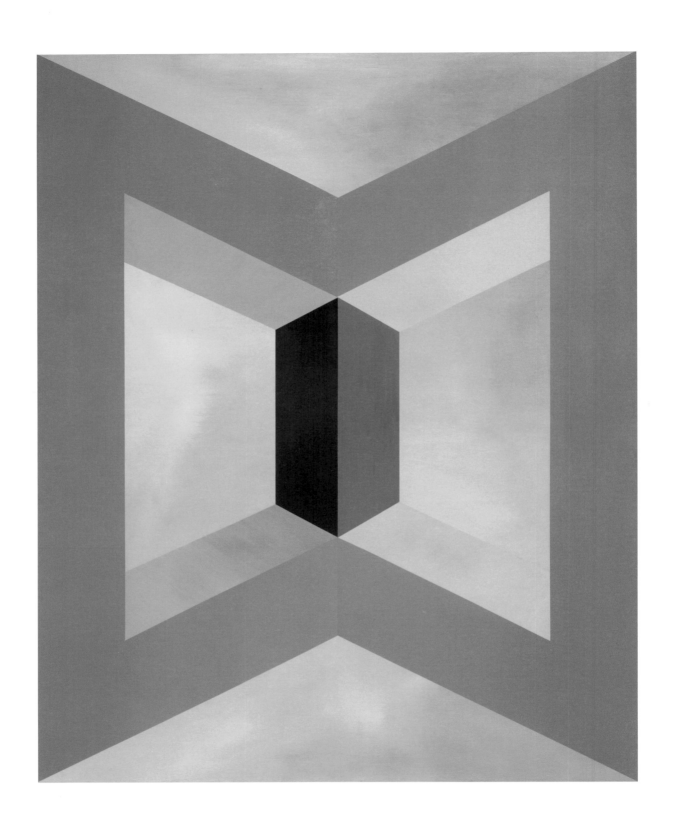

Open III, 1970, Acrylic on canvas, 60 x 48 inches

1970

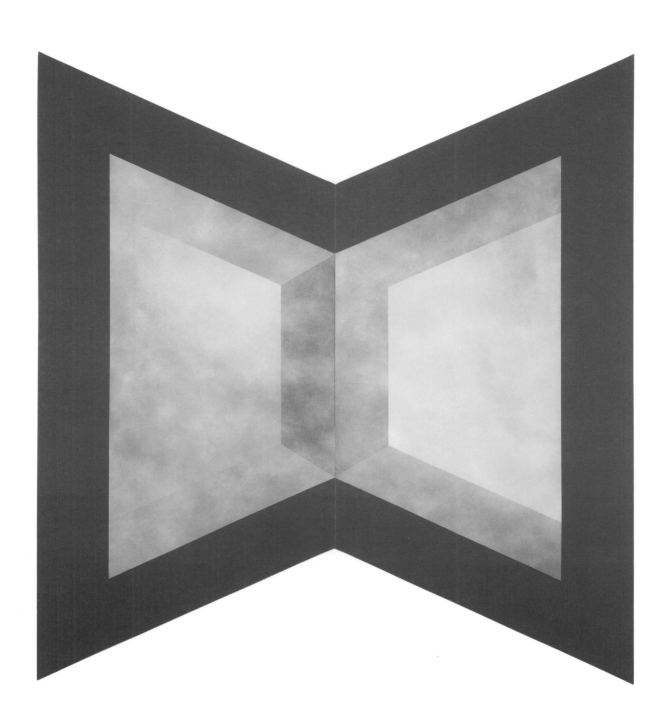

Oracle II, 1971, Acrylic on canvas, 72 x 60 inches

1971

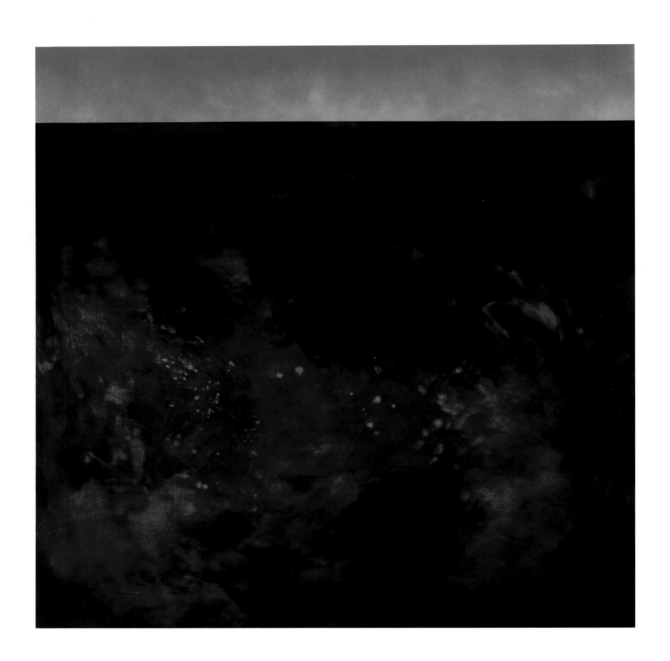

Earth, 1972, Acrylic on canvas, 60 x 60 inches

1972

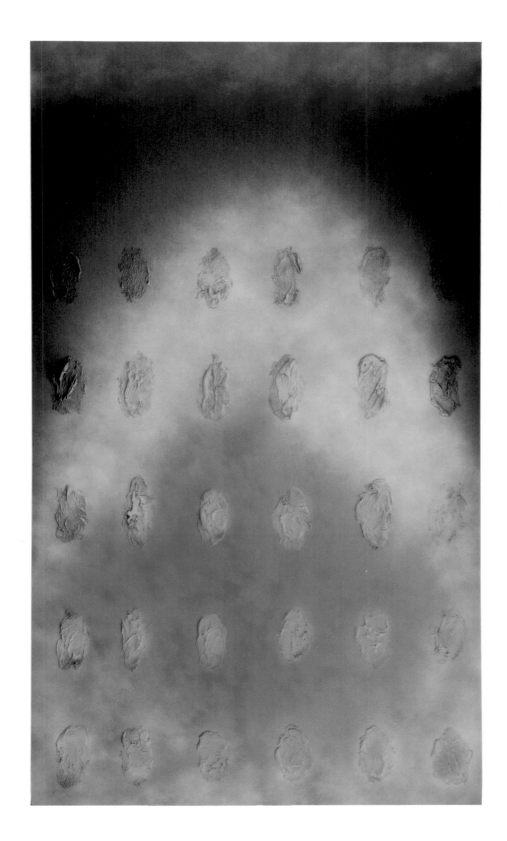

Surge, 1972, Acrylic on canvas, 84 x 48 inches

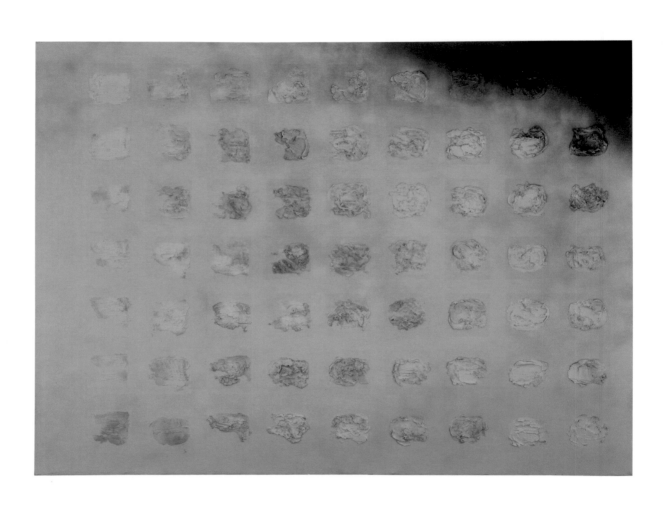

Jet Stream, 1972, Acrylic on canvas, 60 x 80 inches

1972

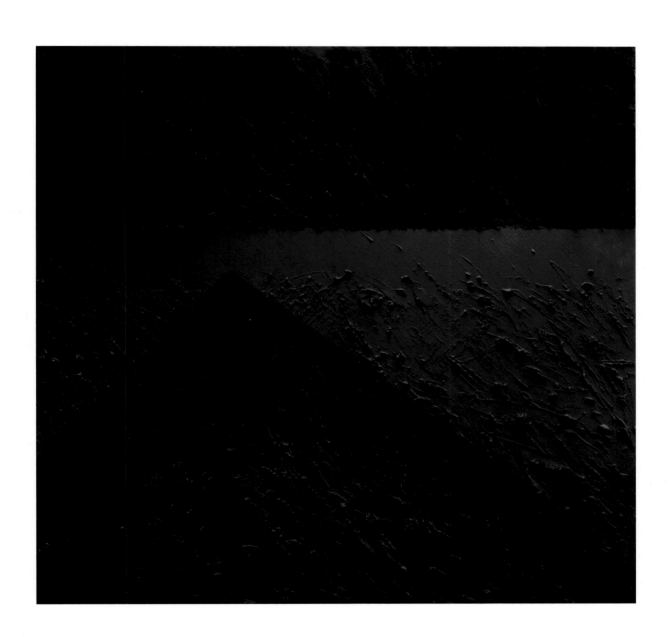

1975

Strata I, 1975, Acrylic on canvas, 48 x 49 ½ inches

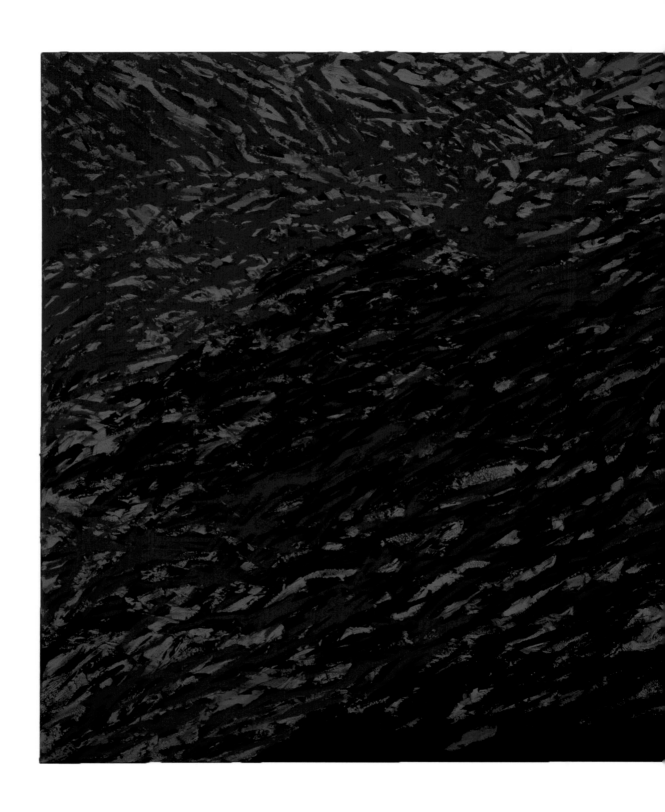

Cross Currents, 1975, Acrylic on canvas, 54 x 96 inches,
Collection Laura Grosch, Davidson, NC

1975

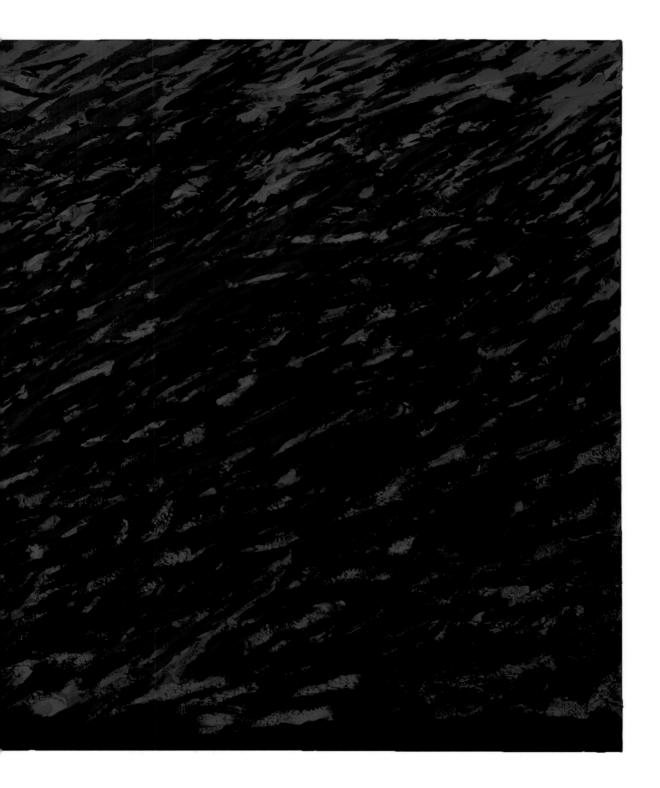

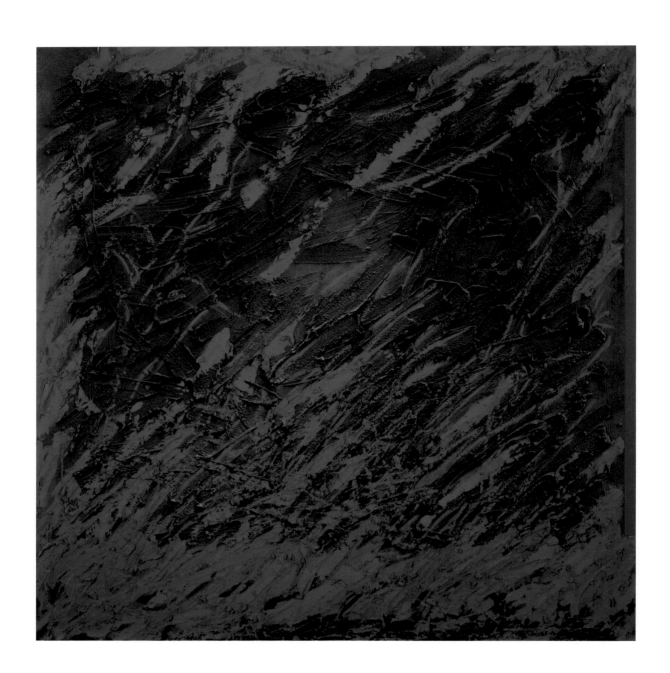

African Violet, 1976, Acrylic on canvas, 52 x 52 inches

1976

Comstock, 1978, Acrylic on canvas, 84 x 48 inches

Tablet, 1978, Acrylic on canvas, 60 x 48 inches

1978

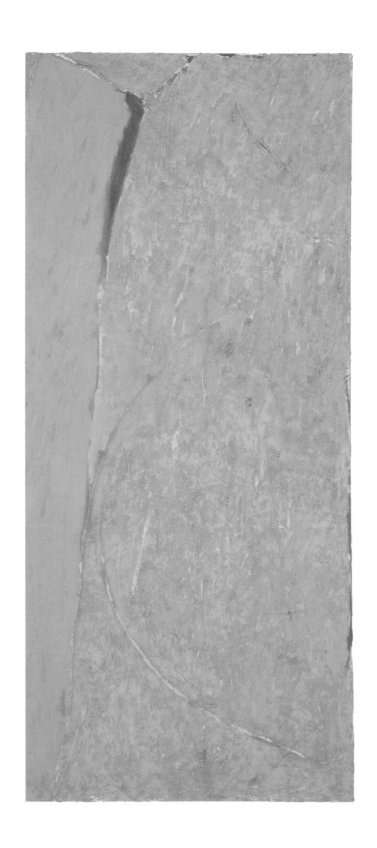

Arc, 1979, Acrylic on canvas, 84 x 36 inches

1979

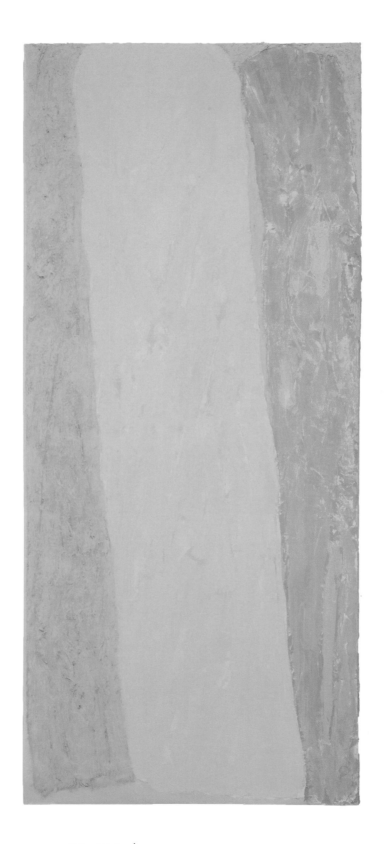

Pilot, 1979, Acrylic on canvas, 84 x 36 inches

1979

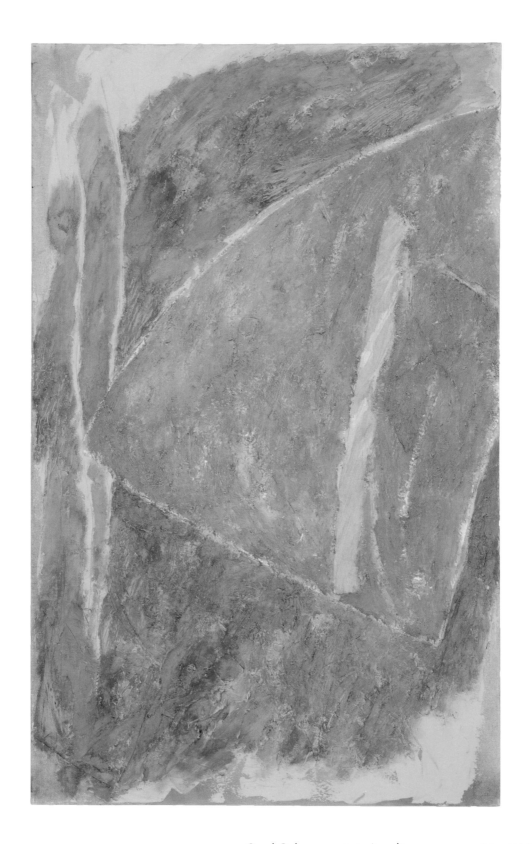

Cool Odyssey, 1979, Acrylic on canvas, 60 x 36 inches

1979

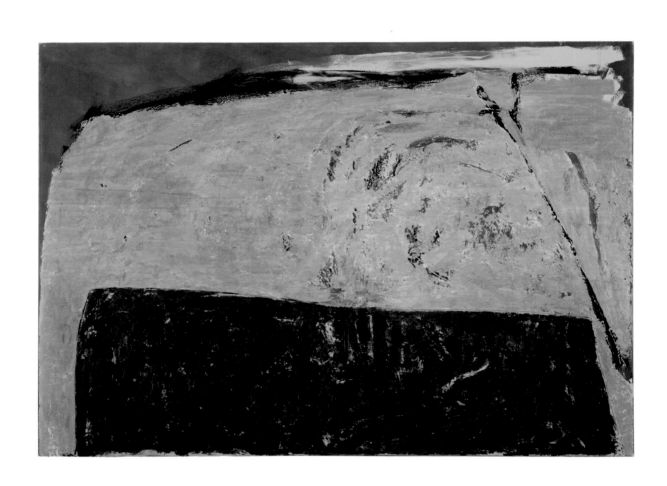

Closer Walk (for Robert Flye), 1980, Acrylic on canvas, 60 x 86 inches,
Collection Van Every/Smith Galleries, Davidson College, Gift of Bill Van Every

1980

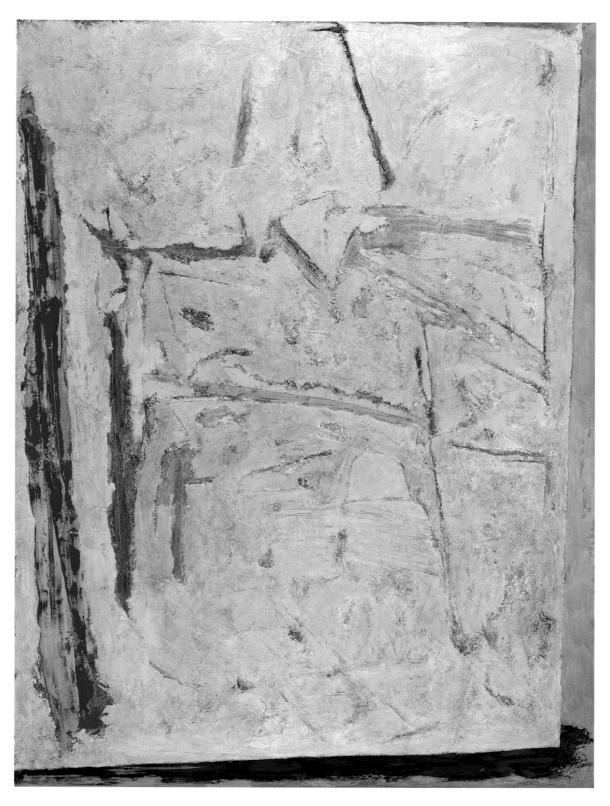

Receiving (for Gene Baro), 1982, Acrylic on canvas, 90 x 66 inches,
Collection Davidson College, Gift of the artist

1982

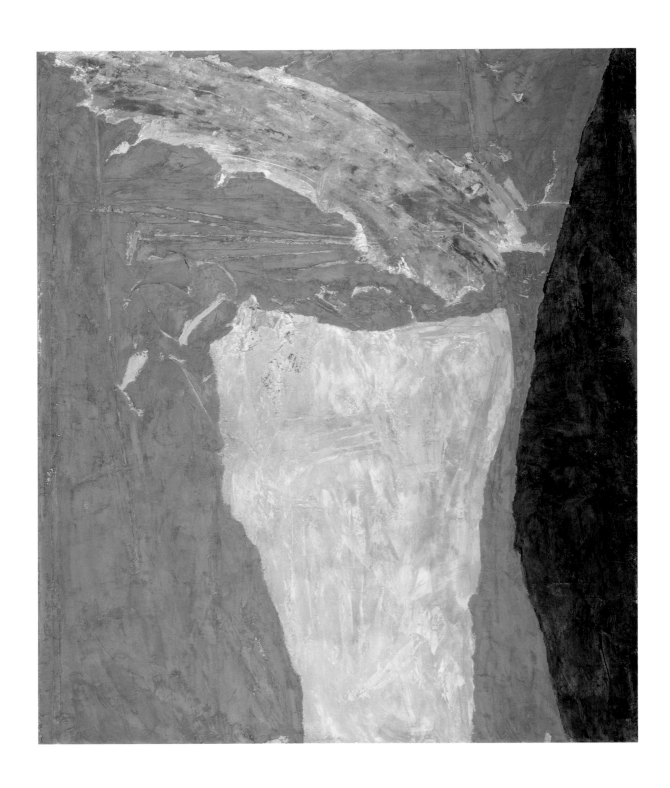

The Light That Burns, 1986, Acrylic on canvas, 72 x 60 inches,
Collection Van Every/Smith Galleries, Davidson College,
Gift of Alida Van Every Woodland

1986

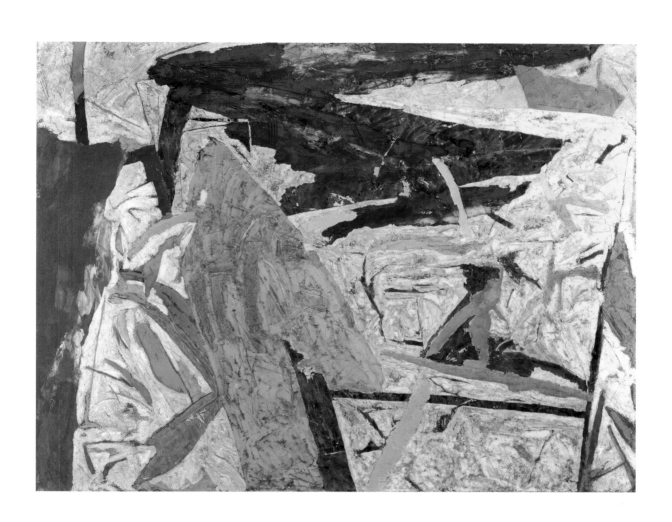

Vulcan's Gate, 1989, Acrylic on canvas, 102 x 132 inches,
Collection City of Charlotte, Douglas International Airport

1989

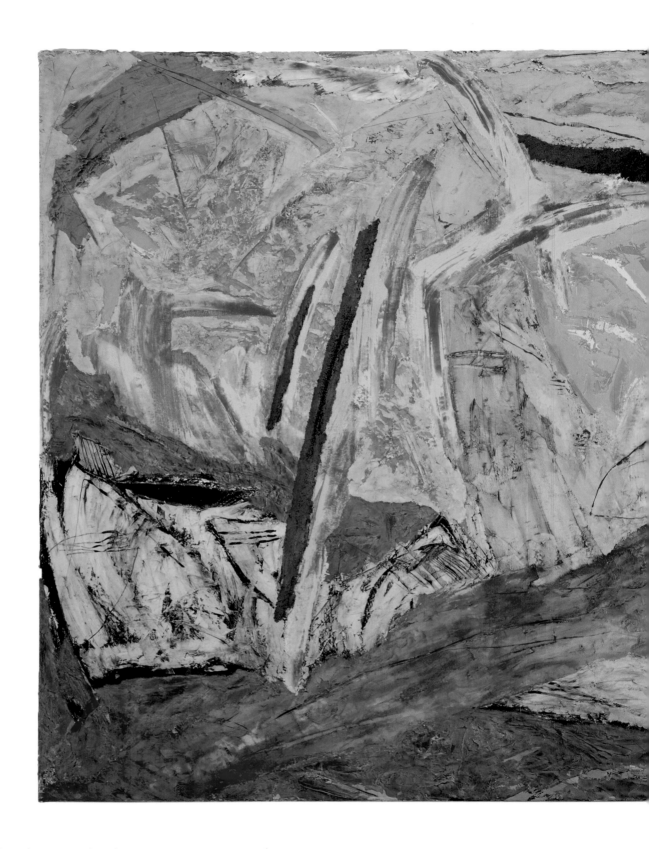

Sisyphus, 1989, Acrylic on canvas, 72 x 120 inches

1989

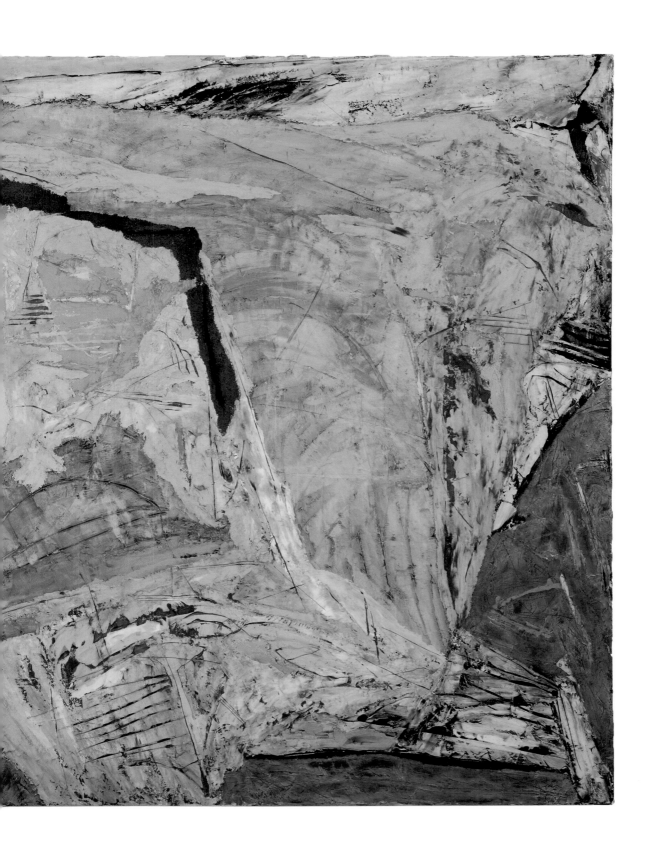

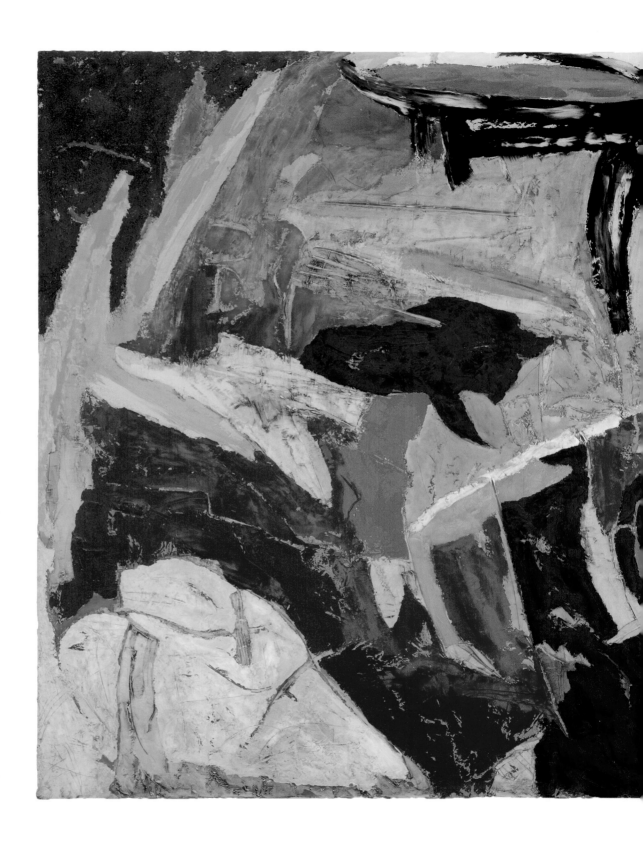

Channel, 1990, Acrylic on canvas, 72 x 120 inches

1990

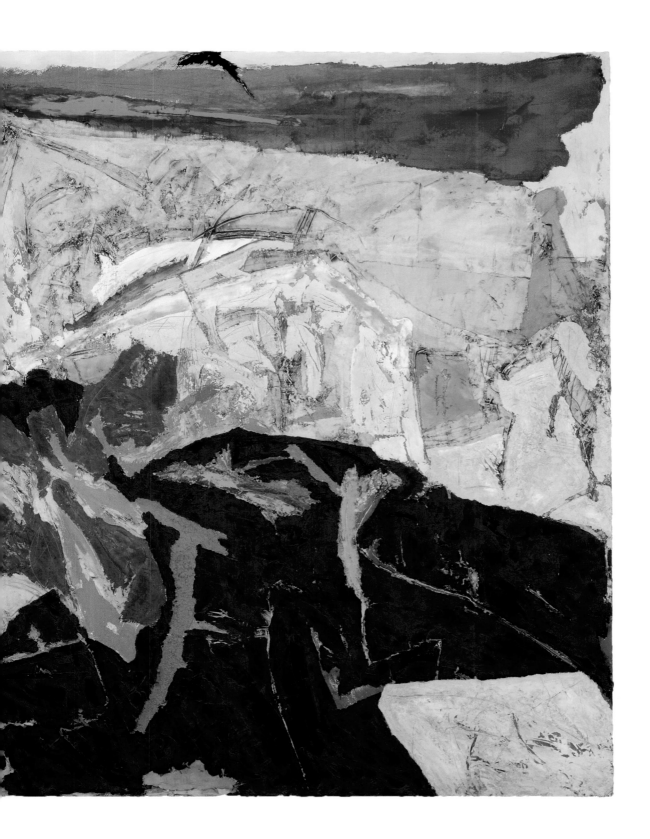

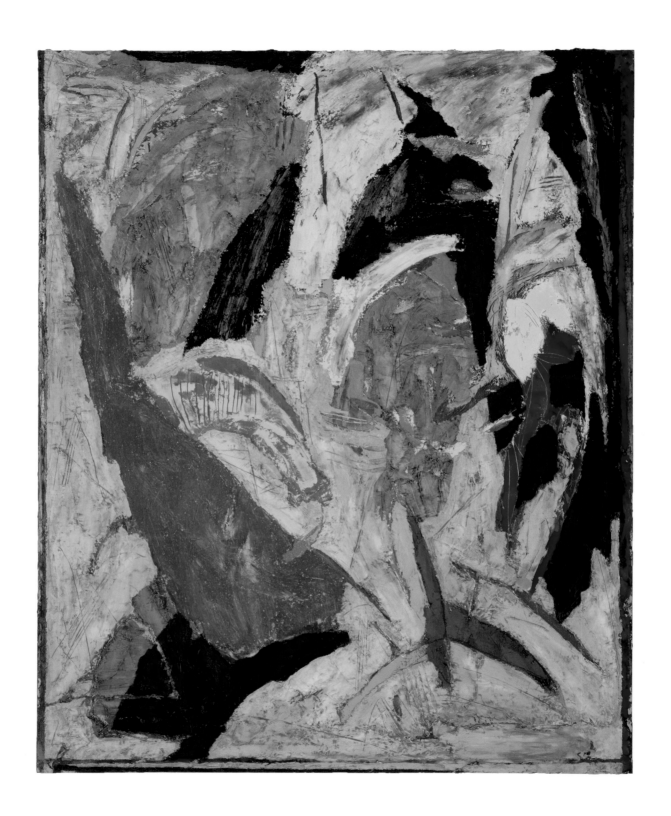

Veronica's Veil C, 1990, Acrylic on canvas, 60 x 48 inches

1990

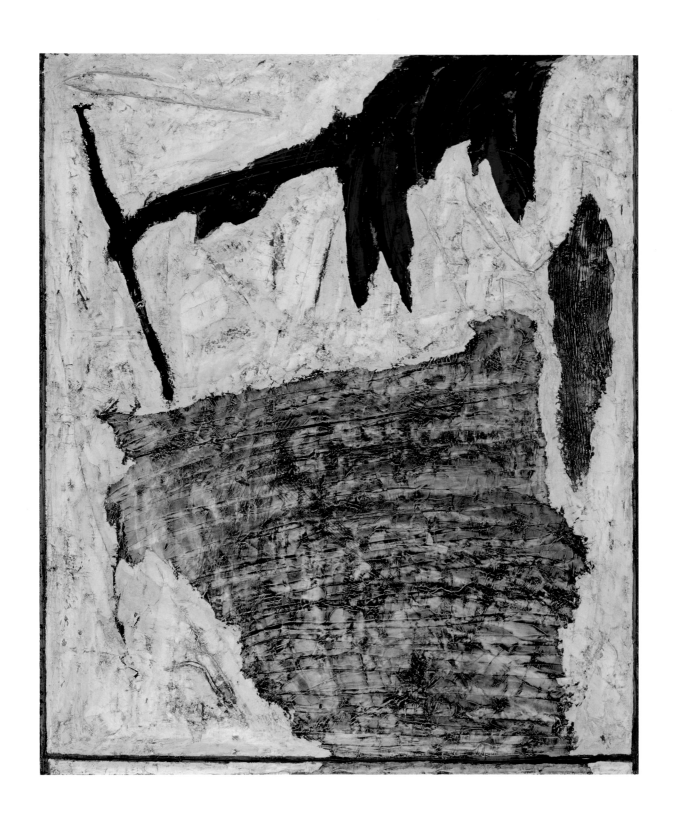

Veronica's Veil CXII, 1995, Acrylic on canvas, 60 x 48 inches,
Collection Jay Everette

1995

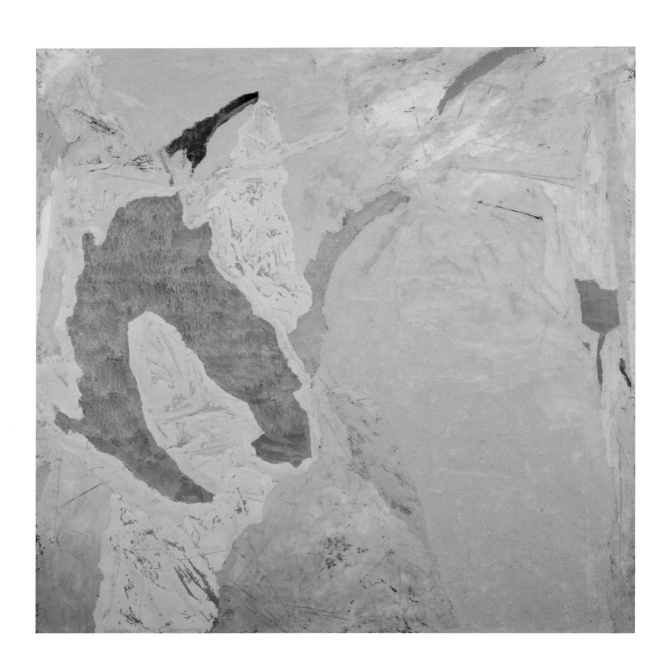

Ivory Trail, 1998, Acrylic on canvas, 84 x 84 inches

1998

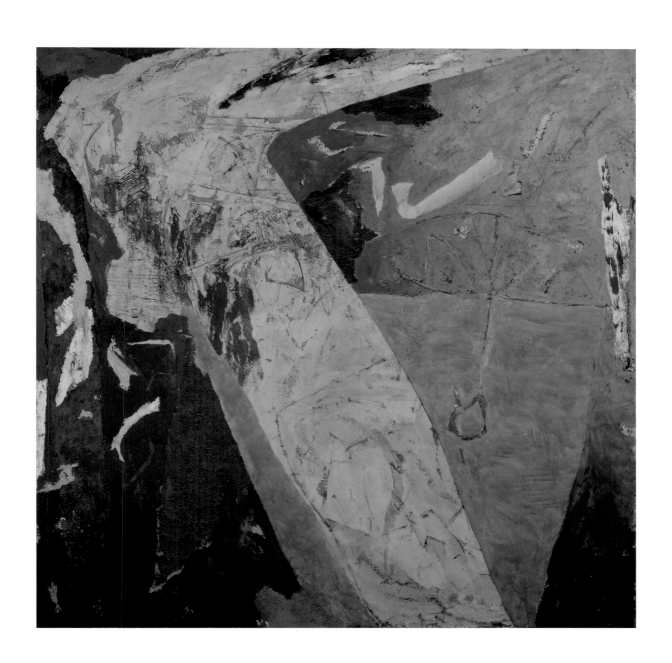

Water Source, 1998, Acrylic on canvas, 84 x 84 inches

1998

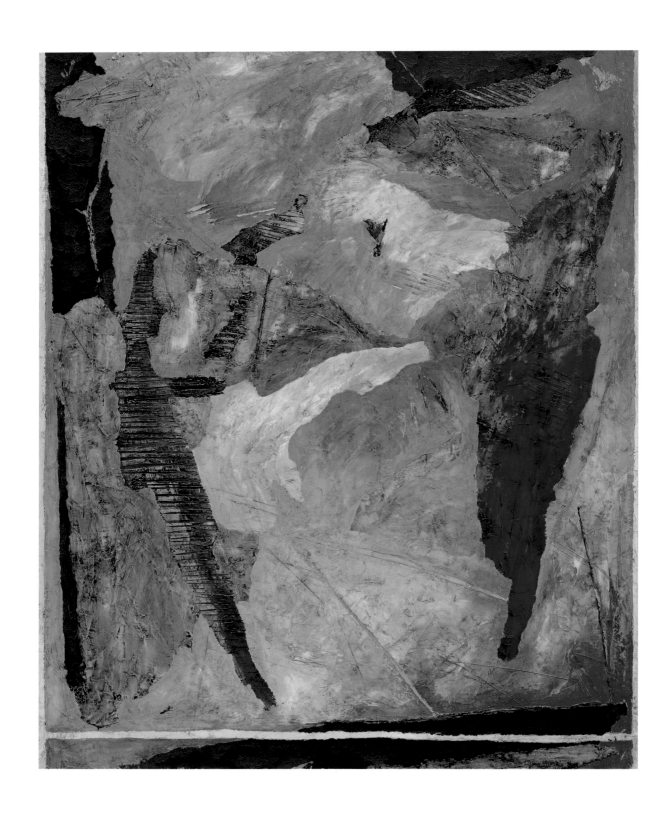

Veronica's Veil CXLIII, 2001, Acrylic on canvas, 60 x 48 inches,
Collection Christa and Bob Faut

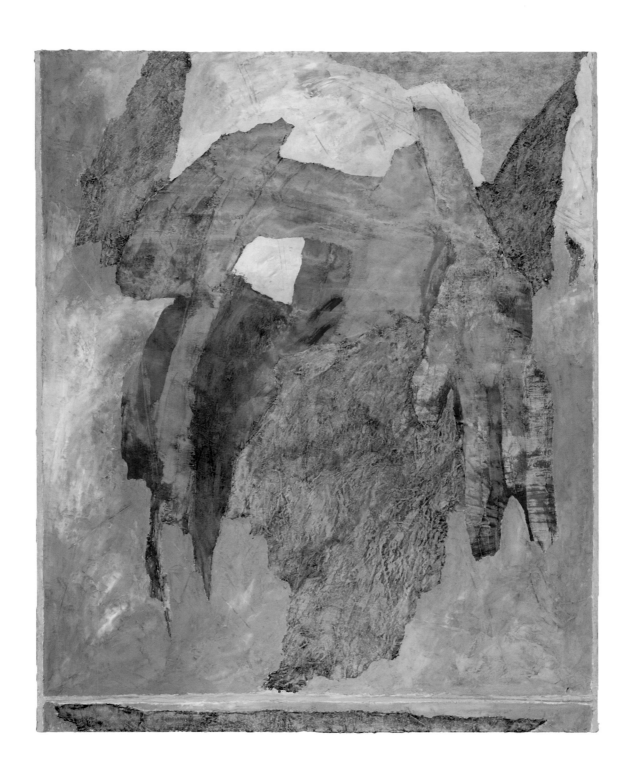

Veronica's Veil CL, 2002, Acrylic on canvas, 60 x 48 inches

2002

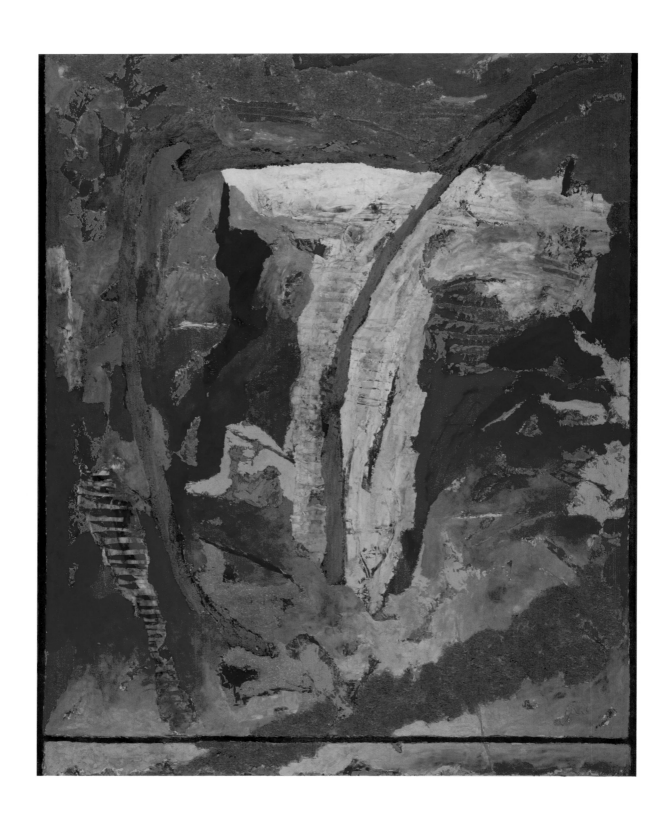

Veronica's Veil CLXV, 2005, Acrylic on canvas, 60 x 48 inches,
Collection Rick and Dana Martin Davis

2005

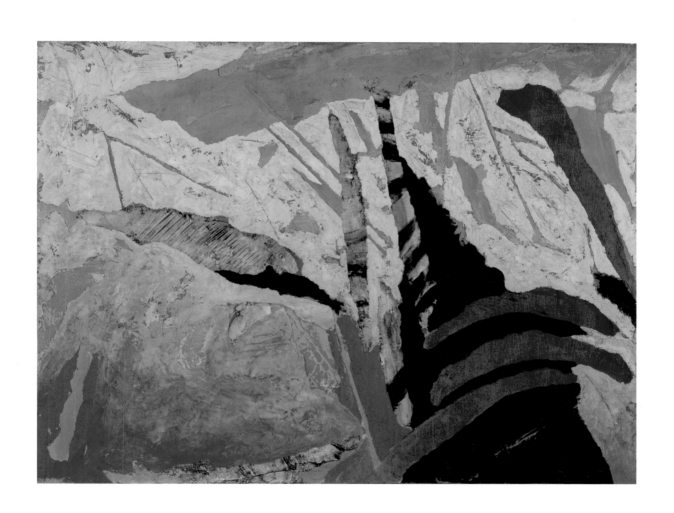

The Danger of Pure Water, 2006, Acrylic on canvas, 38 x 50 inches,
Private Collection

2006

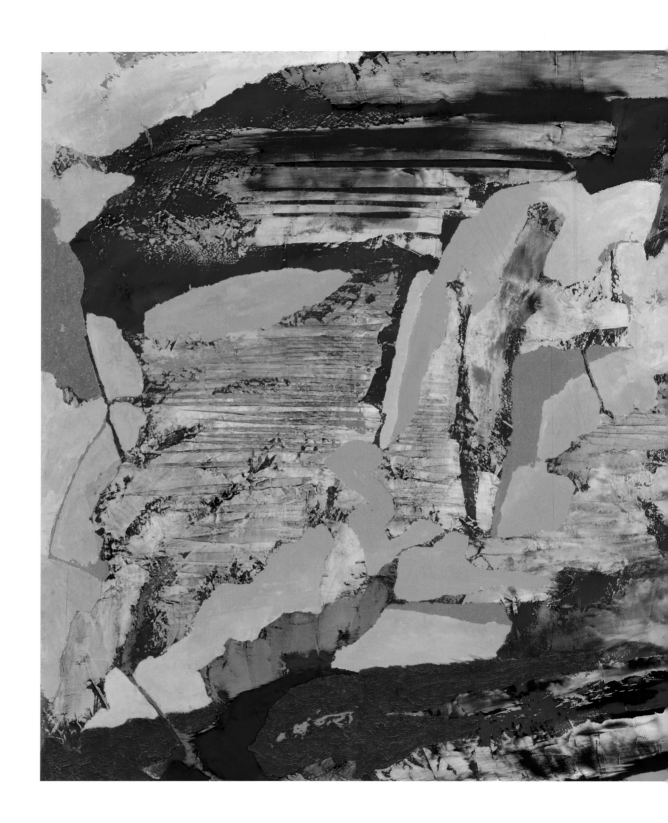

East Wind, 2008, Acrylic on canvas, 48 x 84 inches

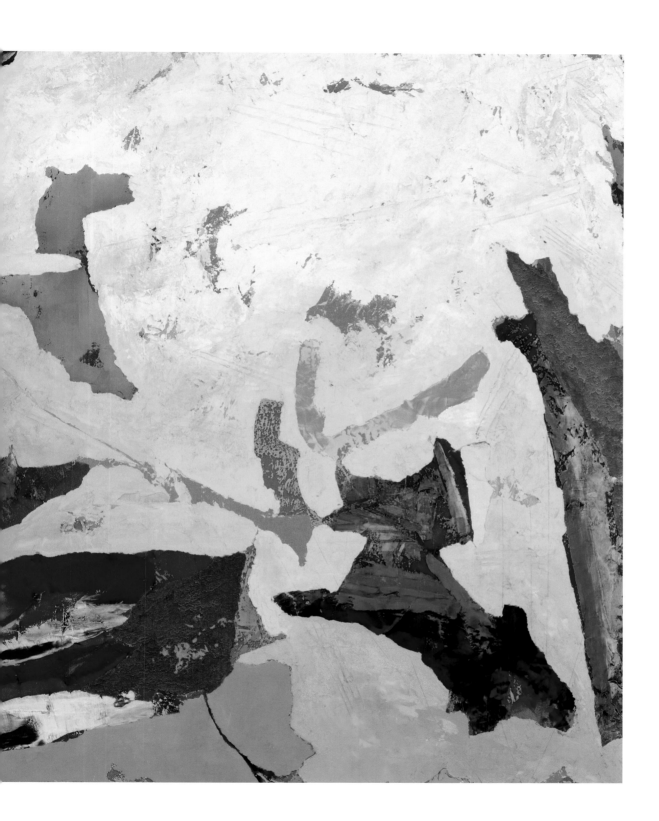

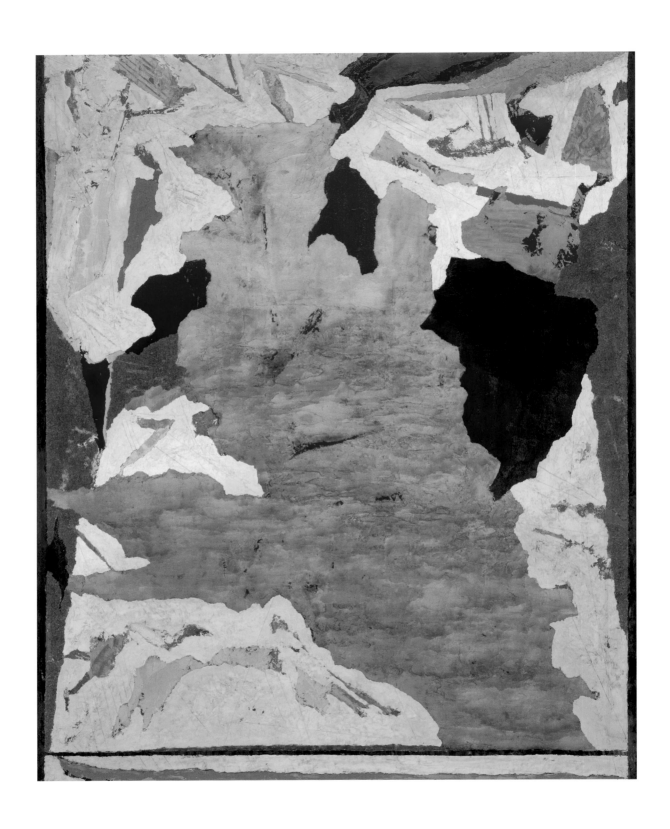

Veronica's Veil CLXXXIX, 2009, Acrylic on canvas, 60 x 48 inches,
Private Collection

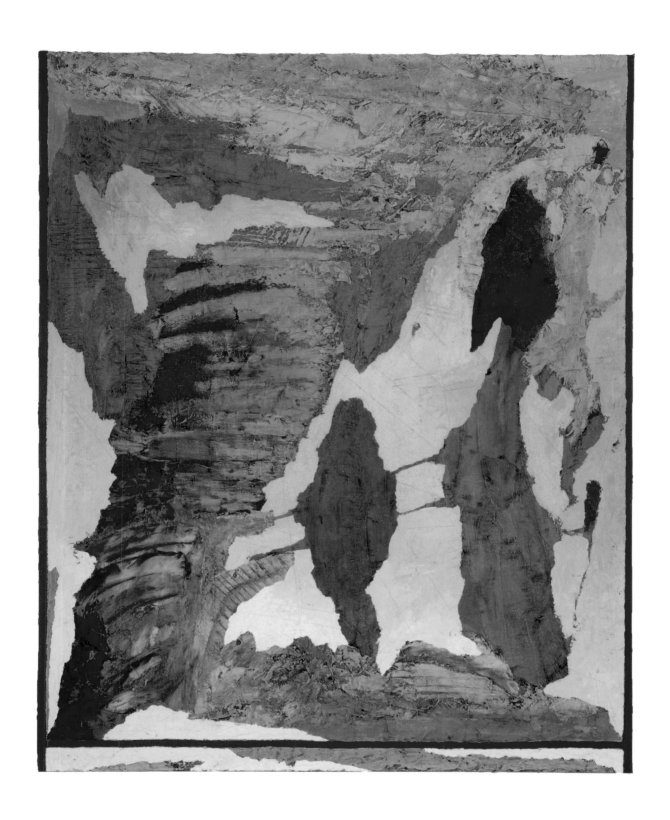

Veronica's Veil CXCVII, 2010, Acrylic on canvas, 60 x 48 inches

2010

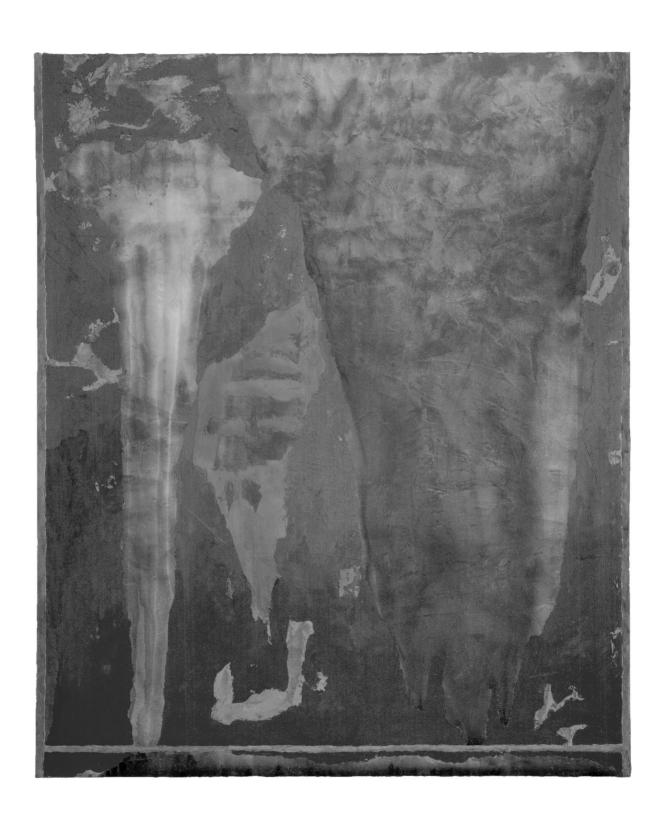

Veronica's Veil CXCIX, 2010, Acrylic on canvas, 60 x 48 inches

2010

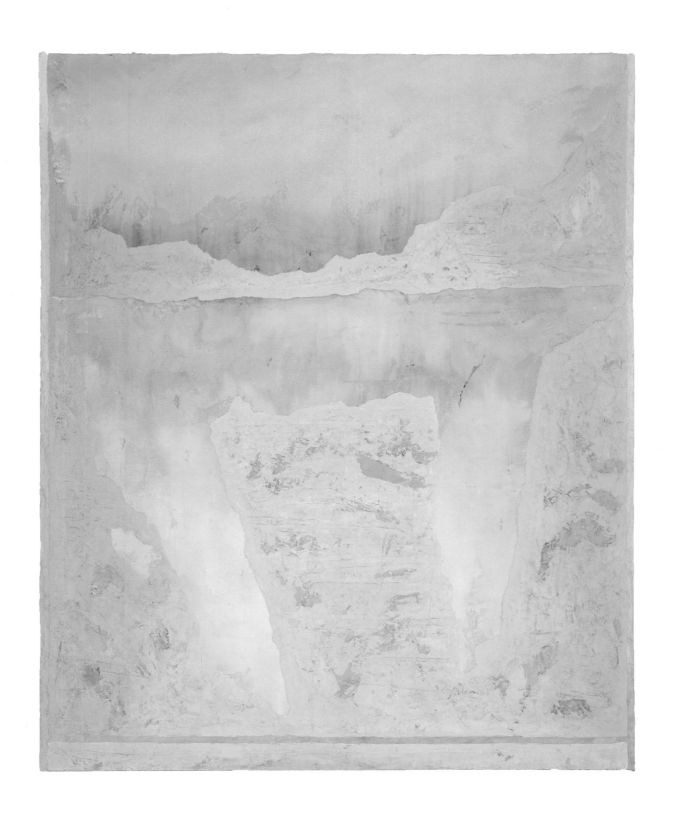

Veronica's Veil CC, 2010, Acrylic on canvas, 60 x 48 inches

HERB AT THE OUTSET

Roger Manley

Experience has two things to teach: the first is that we must correct a great deal; the second, that we must not correct too much. —Eugène Delacroix[1]

First, move your hands. **Then** *the inspiration will follow.* —Jean Dubuffet[2]

Dial back the clock. But there's no need to dial it back; it does that all on its own. At almost any instant—standing blinded in front of an audience in a darkened lecture hall; pulling up in a dusty frontyard to talk to an old woman rocking on a porch; leaning back in a chair (hands clasped behind head) to discuss something with a colleague—an out-of-body flash can sweep you away. You suddenly see yourself doing what you're doing, as secondary thoughts speak from behind the words coming out from your mouth, whispering other words that only you can hear: *Where did this begin? How did I end up here?* Pay too much attention to this other voice or for too long and the past can start to crowd out the present: Behind the podium, the lecture begins to falter; the woman on the porch becomes wary, starts to get suspicious; back at the office, the colleague begins to wonder where you've drifted—the last thing you said a non sequitur.

For want of a nail goes the old proverb, illustrating how one little thing can lead to other, bigger consequences, each triggered by the one before. But what was the nail? What was the first move?

How did all this happen? But, of course, there were always nails upon nails. Better to wait till the show's over, wait till you're back on the highway or safe in your motel room, till after the office has emptied, before you dare to let yourself drift back to look for them, cranking the film backward to see where the chain of events began.

Thinking about Herb Jackson now. We've just spent an afternoon talking, sitting in his bright studio, surrounded by his transportingly vivid paintings. Laughing about things that happened then and since, comparing lives, telling stories. And now I'm back on the interstate, settling into the rhythm of mileposts and signs and letting my thoughts drift back to that first encounter, the first time I met him, a teacher who actually taught me something I hadn't known before.

My freshman year in college: Carnival ride Earth and her companion Moon have do-si-doed about the solar system forty times since then. By now, the memory of those first years that I knew Herb has become a book whose binding has crumbled and pages have loosened. Only scattered scenes remain, not whole plots and passages, and they're mostly out of order. But I've driven I-85 a thousand times or more, back and forth from Durham to Charlotte, Durham to Davidson, Durham to Atlanta, and points beyond, its curves and merges mirrored by well-worn grooves in my cerebral cortex. No real need to be present. I know I'll wake up to reality when its time to find my exit when I reach Durham, so it's okay to let go now and let the clock dial back. Okay to give in, stop thinking from outside, let the scattered pieces of then become here and now.

So, it's freshman year. Nixon is president, and we are losing in Vietnam. The Kent State students are only months in the ground and the Beatles are splitting up. Janis Joplin and Jimi Hendrix have just died, at the same age, of the same causes, within a few weeks of each other. *Star Trek* is already in reruns, but *M.A.S.H.* is still a couple of years away, along with pocket calculators, legalized abortions, the Watergate break-in, and the OPEC oil embargo. For all that is happening in the rest of the world, though, Davidson might as well have been on a lost island, an arcadian enclave of big trees and columned temples. But it's hardly an island paradise, at least not for me. Home with my family at Thanksgiving, I'd had to keep secret how badly things were going, and now that the first of the three terms has ended, the smoke has begun to clear and the full scope of my personal disaster will be engraved upon my grades. After a whiz-kid act in high school—winning science fairs, head of the biology club, class science expeditions to Hawaii, the Nevada deserts, the California coast—I'd arrived for college after a summer in New Mexico, thinking I would major in biology and go on to become a scientist. But there was bad chemistry between me and my first professor, and it wasn't in the Florence flasks and petri dishes that lay scattered around the biology room. The introductory course felt from the outset like wrong-size shoes, the instructor coming across like an angry salesman trying to convince me that my cramped feet would eventually get used to it.

I now realize that I'd missed my era to happily become a biologist. A generation or two earlier and I might have been in my element. Back in high school, I had envisioned myself roaming savannahs in an open jeep or slashing through jungles with butterfly net in hand and a geology hammer tucked behind the Sam Browne belt holding up my jodhpurs, in heated pursuit of the rarest of the rare. But here, all the professor talked about were things I could neither see nor catch: peptides and proteins, carbon rings and nucleic acids, and all of it to me as invisible, abstract, and unknowable as the face of time.

Gaining some measure of self-awareness is, of course, supposedly one of the reasons for going to college. But in the first few weeks of that freshman year, I hadn't yet recognized the need for concrete physicality that would shape most of the rest of my life, and didn't realize this was the real problem. Weeks of frustration dragged by in intro-bio until, in a desperate and completely misguided lateral move, I dropped the course and shifted to advanced calculus. I'd done it because it was the only move I could make—my randomly assigned faculty advisor was a math professor, and could let me into one of his own courses. But it was a classic demonstration of out of the frying pan and into the fire, for now I was drowning in pure abstraction, with not even the reality of molecules to cling to.

This was weeks into the term, and the class had progressed well beyond the introductory phase when I joined it, so every chalk mark the professor made might as well have been a hieroglyph, for all I could make of them. I couldn't even muster an intelligent question: "Sir, could you please explain what 'polynomial' means?" "Mr. Manley, I really can't be taking up our valuable class time with such an elemental issue." I grimly held on, but the approaching end of that first term felt like being swept downstream toward a waterfall: The exams threatened with the sucking roar of inexorable calamity. And with the failure that unavoidably followed came the end of my budding career in science. The *F* headlining the exam loomed in my consciousness like a gallows on a hill or a brand on the forehead.

I mention all this to suggest that not everything that happened afterward was a conscious choice. Burned by fire, you don't need to be told to hunt cool water. In my case, with the left half of my brain seared by abstraction, I reached almost helplessly toward anything real, anything I could hold in my hand. Like, for instance, a brush or a gouge, or a piece of charcoal. Making and doing felt intuitively like an antidote to thinking—or, at least, to the kind of rational thinking that formulas and equations demanded. In the course catalog, I saw the listing for a class in basic studio art, and instinctively signed up for it.

If dropping science and failing math had been the nail, this was the shoe—but a lucky horseshoe, for how things eventually turned out. On the first day of the new term, at the front of the single room on the entire campus that had been set aside for the visual arts, stood a young instructor, still only in his second year of teaching. Dark-haired, mustachioed, dressed in a blazer, open-collared shirt, and jeans, he was the first professor I'd seen without a tie. In fact, he was only a few years older than the students

in his class, and had just completed his graduate degree. Speaking in a voice that could be the text-book definition of "sonorous"—a rounded, rich sound that paused a moment before emerging, almost always to deliver an epigrammatic response that could be, by equal turns, wittily wry and oracular or cuttingly blunt—Herb Jackson was the most charismatic and mysterious person I'd ever met.

His was also the strangest class I'd ever taken. I don't recall that there were any lectures or handouts; if there were, I didn't save the notes. I'm not even sure if there was a textbook or not, but I doubt it. Slides may have been projected at some point or other, but if they were, there was no emphasis on dates or discussions of styles or schools of painting. What I do remember was the dive-in-and-do way he led us into the world of art. It was: Look and see, but move your hands; look, then *do* something; see, then *make* something. There were exercises—making a drawing with only contour outlines; drawing only shadows; drawing only the negative spaces between things; keeping on drawing until no more white remains on the paper and then begin undrawing with an eraser—but these were only to set us in motion. Herb somehow knew that art could not be approached directly, but that one might sidle up to it through action. He understood how *doing* could lead to *being*, and how making might eventually result in becoming. One becomes an artist by making art—a truism that is far less obvious than it seems. First, one must start with the making—period. By creating conditions in which one could discover this for himself, Herb made art seem important enough, but also doable enough, that one could begin to imagine reorienting a life to pursue it.[3]

As far as I could tell, nothing else was being taught this way at the time. Math and science students weren't expected to make discoveries or breakthroughs in their studies, but only to study and memorize a set of specialized procedures and learn enough jargon to catch up with their particular fields when they finally reached graduate school. Religion students weren't required to generate new beliefs or lead actual worship services, nor were any demands made on students of English or foreign languages to create new literature. But no student of Herb's could escape at least making the effort to actually do something original and personal, even if it wasn't "fine art" or even "good art" in the same sense that others would appreciate it. Students in his classes found themselves struggling with brushes and burins, mixing colors and wiping inky metal etching plates, in an effort to make things that couldn't be rendered in words or numbers. And, once started, the only way out that he permitted was *through*—for just as falling teaches walking, Herb knew that the struggle itself provided the moments of discovery. Because of this, he didn't allow anyone to give up. "I'm not your teacher," he'd say. "The bad painting is your teacher. If you quit and throw it away, you're killing your teacher. Pay more attention to what it's trying to tell you."

While we were, in one sense, teaching ourselves (or, rather, being taught by our own efforts, with Herb acting more as adviser than instructor), he also taught by example. At one end of the same large

room crammed with the easels and drawing boards of his students, Herb worked quietly and steadily on his own prints and paintings between classes. Watching him go through the acts and motions himself, we began absorbing and imprinting—learning the muscle memory—of making art, like amateur golfers learning to improve their strokes by watching looped videos of professionals completing their swings. With Herb working alongside us, we could not only see that almost nothing turned out an immediate success but also how one learned to work *with*, not *on* a painting, etching, or aquatint. Each painting and print went through stages ("states," in printmaking terms) as the images gradually refined and emerged.

For most of us, who had never been around a working artist, seeing an adult apply this kind of deliberate and dedicated effort to art-making was a revelation. Unless one shares a house or studio with an artist, it is rarely possible to observe a writer, painter, filmmaker, or composer—indeed *any* creative worker—going through the whole process of exploring new approaches, reaching dead ends, finding creative solutions, and editing and refining to reach a satisfactory result—that is, all the steps that are always a part of true art-making. We've all seen hack artists on TV wielding sponges and palette knives to crank out chalets and mountain lakes or stands of bamboo in a matter of minutes that would do any motel room proud, seen practiced potters pulling up pots on their wheels, and watched gifted rhymesters generate couplets in a matter of seconds, but we almost never get to see the prolonged work and thoughtful effort it takes to get beyond kitsch, production craft, or rhyming doggerel to come up with something more significant. The result is that most people think of art as only a gift, like red hair, instead of as something achieved through regular, committed effort. Because Herb had been making art for so long—selling work before he was twelve, winning first place in the North Carolina Museum of Art annual juried show when he was just sixteen (while the other place winners were all middle-aged professionals)—he'd had enough experience to develop confidence in his process to the point that he could work with undergraduate students in the room, which gave us a chance to see how it really happens.

In those early years of his teaching career, it was still possible to see Herb's art change and develop at a relatively rapid pace. Between the time I started college and graduated, his work evolved from his early cloudlike paintings, with smooth surfaces, soft, high-key colors, hard edges, and airy illusionistic spaces that flipped between levels and perspectives, into the experiments with vivid and intense colors that led to his *Elements* series. These then gave way in turn to somber walls of dark paint with dollops of thick impasto that contrasted with mists of paint sprayed from a can. The "excavation" technique that led to Herb's *Veronica's Veil* series would not emerge for several more years, although the seeds were already planted in his drawing and undrawing persistence and in experiments with oil crayons that he had just begun to explore. Watching each of these strategies evolve literally before our very eyes taught more than any texts could teach about the making of art.

Art is both an individual effort and a way to share—or, at least, that's how Herb made it feel. By junior year, the college had agreed to let painting and sculpture be taught in Lingle Manor, an old, abandoned two-story house already slated for demolition (and now long gone), just across the street from where Tomlinson dorm is now. Enrollment in the art classes came with a key to the house, and having access to it at any hour of the day or night felt like being let in on a shared secret or belonging to a closed guild. The house hadn't been repaired or repainted in many years, and knowing that it would eventually be torn down gave us the freedom to make the kind of creative messes that might have been inhibited in more pristine studios. With the building dimly lit and neither heated nor air-conditioned, we huddled in heavy coats in winter and sweltered in early fall or late spring, but loved working in the old house for its authentic "this is *real* art-making" ambience that we naturally associated with Parisian garrets and New York lofts.

In my own room at the Manor, I made powdery rubber prisms from truck inner tubes cut and peeled back like skinned seals suspended from the ceiling, constructed house-of-card-like lean-tos of found wood, and laced cloth over wire armatures. In the next room over, an older student, whose name has long escaped me, kept hot wax constantly warming in a crock pot, which he shaped by hand and then smoothed with a propane torch to make lost-wax molds. I wanted to try it, so he gave me enough wax to make a pair of entwined figures. These just barely fit into a large metal can that I filled with wet plaster to make my own mold. Two other art students[4] let me burn out the wax in the oven of their off-campus kitchen, and then melt lead scraps in an old pot on their stovetop burners to pour into the cavity left in the plaster. After it cooled, I chipped away at the mold to expose the now-metallic leaden figures that had replaced the wax. In so doing, I came a little closer to understanding how Rodin or Cellini must have felt when freeing their own huge bronzes from their molds as well. It didn't matter that my clumsy efforts at casting hot metal were leagues away from being masterpieces. Making the effort—actually *doing* something, as Herb constantly encouraged—left me with a respect for their achievements that I could never have garnered any other way.

Happily, that respect didn't stymie creativity with overseriousness. Although Herb could cut sharply with a witty bon mot, especially during our weekly critique sessions if he thought someone was hiding behind bullshit, the remarks were almost always in the service of cutting the student free— either from mistakes and preconceptions that might be holding him back or, perhaps more important, from overdependence on Herb's guidance and approval. At some point, the gymnastics coach must stop catching, step away, and let one hit the mat in order to teach how important it is to keep catching the bar.

I-85 narrows from eight lanes to four to cross a bridge at Spencer, but in my reverie I scarcely notice. I'm still at Davidson, three years after meeting Herb. At the end of junior year, I'm one of six guys who apply for and get permission to live in a college-owned property on North Main Street, eponymously called North Main House, just two doors up from Herb and Laura Grosch's house, which is equally old and also college-owned. Before we leave for summer break, we borrow a rototiller and plow up the backyard to plant a garden. Fragments of old rusted tools, hinges, bottles, and charred wood come to the surface during the tilling to reveal the forgotten location of an old shed that had once stood there before it burned many years ago. Potash, which had leached out of the burned lumber, turned out to be a perfect fertilizer for okra. The okra we plant in the backyard's fire-darkened soil grows so rapidly over the summer, while we are gone, that when we return in the fall to move into the house, it is so lush and tall that we need a stepladder to pick it. Our tomatoes and melons are a success as well. We can't eat it all, in fact, nor keep up with the constant production. So, nearly every week until frost, I take baskets of excess okra and tomatoes to Herb and Laura's down the block whenever they invite me over for breakfast. I put on a Harris Tweed jacket with professorial elbow patches, wanting to look like I appreciate the privilege, which I do.

Usually Laura answers the door. A double portrait of her and Herb hangs in the entry hall, with a gilded background like a medieval altarpiece. There's more art down the hall and up the stairs. Their house was the first I'd ever seen that was filled with art. Laura leads me back to where Herb is sitting in a white Eero Saarinen chair, reading the paper and drinking orange juice. The kitchen and breakfast table are in an extension off the back of the house, surrounded by bright windows with sills lined with Laura's plants. The smell of eggs and bacon fills the room. Cut cantaloupes and biscuits rest on platters on the table. A cat wanders through as I'm buttering a biscuit and telling some story about a recent camping trip. Herb puts down his paper, and suddenly asks, "So, how are your grades? What did you make this term?" Laura smiles and frowns at the same time, and says, "Herb! You can't ask him that. He's not your son!" Herb goes back to reading. "Well, he needs to pay attention."

I momentarily pay attention now as the sign indicating the exit for High Point flashes by. Halfway back to Durham, and another hour to go. Plenty of gas and I'm not hungry, so I go back on mental autopilot and drift backward in time once again. Another nail or lucky horseshoe . . . hard to tell which. A step or a beginning?

It's 1974 and it's graduation day, and I'm sweltering in the cheap black nylon robe on top of my suit and tie. We've already graduated—already proceeded past the professors lined up in ranks leading to the rows of folding chairs arranged under the trees, where our parents and siblings had waited to watch us called forward one at a time to shake the president's hand and receive our diplomas. It's over now and we're standing in clumps, not sure what to do next. Something feels incomplete about it all. I've got the parchment in my hand, but I don't feel any different. It's not quite what I expected. Neither relief, nor a sense of accomplishment, nor any feelings of either sadness or anticipation. It's over, but somehow it doesn't feel over.

Killing some time before I have to get in the car with my family and leave for good, I lead them on a short stroll around the campus, revisiting the dorms for the last time, entering Eumenean Hall and Dana Science Labs, where my biology career had come to its end, pointing out the shrouded stone maidens flanking the seal over the entrance to Chambers. Still nothing. Then, we head across the grounds to the room in Cunningham where I had taken that first art class. Herb is already out of his own robe, busy working on a Cray-pas drawing. He looks up and pauses long enough to shake my father's hand, then glances in my direction. He smiles. "He's on his own now," is all he says, but like so many other things he'd said the four years leading up to this, it was exactly what I needed to hear. Davidson was now behind me, and all the rest lay ahead.

At Davidson, Roger Manley was president of the Eumenean Society and one of four students who founded the Outing Club. Before settling down to marriage and regular employment, he spent many years living with and photographing Australian Aborigines, Navajos, Gullah Sea-Islanders, Hispanic migrants, Inuits, and Palestinian villagers, curating exhibitions, writing books, and making documentary films. He founded the Meta Gatherings at Black Mountain, and is now the director of the Gregg Museum of Art & Design at North Carolina State University.

Notes

1 "Il y a deux choses que l'expérience doit apprendre: la première, c'est qu'il faut beaucoup corriger; la seconde, c'est qu'il ne faut pas trop corriger," *Journal de Eugène Delacroix*, March 8, 1860.

2 "Tout d'abord, déplacez vos mains. APRÈS, l'inspiration viendra." Gallery talk by the artist at the opening of *Jean Dubuffet: 1941–1960*, Musée des Arts Décoratifs, Palais du Louvre, Pavillon de Marsan, held December 1960–February 1961. Transcribed by Pierre Carbonel; conveyed by email.

3 In this case, "himself" is accurate. Davidson did not become coeducational until the following year, and even then fewer than two dozen women enrolled.

4 Kes and Missy Woodward. Kesler Woodward entered Davidson as a chemistry major, but ultimately majored in art. Kes has written that Herb Jackson "convinced me by example—in his work and in his teaching—that art was something a bright, ambitious person might spend his life trying to do . . . that inspiration comes in doing the work, rather than needing to be found before starting." Kes taught art for twenty years at the University of Alaska, and remains a professional painter. He has been awarded the Alaska Governor's Art Award for Lifetime Achievement. His wife, Marianna "Missy" Boaz Woodward, also majored in art, and became the first woman ever to graduate from Davidson. She was a full-time studio potter for a number of years before deciding to return to school to earn her M.D. Missy practiced medicine at the Tanana Valley Clinic and Fairbanks Memorial Hospital for seventeen years, until her sudden death in late July 2010.

Another noteworthy classmate was Ken Freed. Kenneth Freed, who intended to major in psychology and religion, had originally planned to become a Presbyterian minister, but instead became one of the first to graduate from Davidson with a B.A. in art. He went on to become a professional painter as well as adjunct professor at Western Michigan University and Kalamazoo College. He remains on the faculty of the Kalamazoo Institute of Art.

HERB JACKSON

Born 1945, Raleigh, NC
Lives and works in Davidson, NC

EDUCATION

M.F.A., University of North Carolina, Chapel Hill, NC, 1970
B.A., Davidson College, Davidson, NC, 1967
Philips Universitat, Marburg, West Germany, 1965–66

SOLO EXHIBITIONS (selected)

Firestorm in the Teahouse, Claire Oliver Gallery, New York, NY, 2011
Ten Days: A Collaboration with Herb Jackson and Alan Michael Parker, Davidson College, Davidson, NC, 2011
Excavations, Van Every/Smith Galleries, Davidson College, Davidson, NC, 2011
Dream Point, Christa Faut Gallery, Charlotte, NC, 2010
Come Up and See My Etchings, Davidson College, Davidson, NC, 2009
The Family Jewels, Christa Faut Gallery, Charlotte, NC, 2009
New Paintings, Davidson College, Davidson, NC, 2008
Veronica's Veils, Art Space, Raleigh, NC, 2008
Paintings, Cline/Dale Fine Arts, Scottsdale, AZ, 2007
Veronica's Veils—A Retrospective, McColl Center For Visual Art, Charlotte, NC, 2007
Veronica's Veil Drawings, Christa Faut Gallery, Cornelius, NC, 2007
New Paintings, Somerhill Gallery, Chapel Hill, NC, 2006
Drawings from the Adriatic, Davidson College, Davidson, NC, 2006
Small Oil Paintings, University of the South, Sewanee, TN, 2006
Small Paintings, Stetson University, Deland, FL, 2006
Paintings, Christa Faut Gallery, Cornelius, NC, 2005
Small Paintings, The Art Preserve, Charlotte, NC, 2004
Recent Paintings, Les Yeux du Monde, Charlottesville, VA, 2004
Veronica's Veils, Christa Faut Gallery, Cornelius, NC, 2003
Small Oil Panel Paintings, Hickory Museum of Art, Hickory, NC, 2003
Herb Jackson: The Artist, Fayetteville Museum of Art, Fayetteville, NC, 2002
Large Drawings, Christa Faut Gallery, Cornelius, NC, 2002
Drawings, GSI Fine Art, Cleveland, OH, 2001
Small Paintings, Parchman Stremmel Gallery, San Antonio, TX, 2001
Drawings, Les Yeux Du Monde, Charlottesville, VA, 2001
Oil Panels, Morris Gallery, Columbia, SC, 2000
Small Paintings, Greenville Museum of Art, Greenville, NC, 2000

Paintings, Christa Faut Gallery, Cornelius, NC, 2000
Paintings, Lamar Dodd Art Center, LaGrange College, LaGrange, GA, 1999
Paintings, Louisiana Tech University, Ruston, LA, 1999
New Paintings, Jerald Melberg Gallery, Charlotte, NC, 1999
Paintings, Somerhill Gallery, Chapel Hill, NC, 1998
Paintings and Works on Paper, Jerald Melberg Gallery, Charleston, SC, 1998
New Paintings, Les Yeux du Monde, Charlottesville, VA, 1998
The Figure, Christa Faut Gallery, Davidson, NC, 1997
Drawings from Hawaii, Jerald Melberg Gallery, Charlotte, NC, 1997
New Drawings, Halsey Gallery, College of Charleston, SC, 1997
Veronica's Veils, Cumberland Gallery, Nashville, TN, 1996
Paintings and Small Drawings, Jerald Melberg Gallery, Charlotte, NC, 1996
Recent Paintings, Somerhill Gallery, Chapel Hill, NC, 1995
Drawings and Paintings, Les Yeux du Monde, Charlottesville, VA, 1995
New Paintings, Parchman Stremmel Gallery, San Antonio, TX, 1995
New Paintings, Jerald Melberg Gallery, Charlotte, NC, 1994
Small Paintings, Peden Gallery, Raleigh, NC, 1993
New Monotypes, Christa Faut Gallery, Davidson, NC, 1993
Jackson Squared, Jerald Melberg Gallery, Charlotte, NC, 1993
Paintings, Fay Gold Gallery, Atlanta, GA, 1992
Veronica's Veil Series, Peden Gallery, Raleigh, NC, 1991
New Paintings, Phyllis Weil Gallery, New York, NY, 1990
Allene Lapides Gallery, Santa Fe, NM, 1989
Dream of the Minotaur, Jerald Melberg Gallery, Charlotte, NC, 1988
Drawings, Phyllis Weil Gallery, New York, NY, 1988
Veronica's Veils, Judy Youens Gallery, Houston, TX, 1988
New Paintings, Fay Gold Gallery, Atlanta, GA, 1988
Recent Paintings, Phyllis Weil Gallery, New York, NY, 1987
Graphic Images, 1970-1986, Jerald Melberg Gallery, Charlotte, NC, 1987
Cumberland Gallery, Nashville, TN, 1987
New Drawings, Gilliam Peden Gallery, Raleigh, NC, 1987
Veronica's Veils, Fay Gold Gallery, Atlanta, GA, 1986
Edmonton Art Gallery, Edmonton, Alberta, Canada, 1985
Veronica's Veils, Jerald Melberg Gallery, Charlotte, NC, 1985
Animistic Vision, Phyllis Weil Gallery, New York, NY, 1984
Tropical Fish, Jerald Melberg Gallery, Charlotte, NC, 1984
Reading Public Museum, Reading, PA, 1984
Fundacio Calouste Gulbenkian, Lisbon, Portugal, 1984
Phyllis Weil Gallery, New York, NY, 1983
National Academy of Sciences, Washington, DC, 1983
Mint Museum of Art, Charlotte, NC, 1983
Springfield Museum of Art, Springfield, MO, 1983
Asheville Museum of Art, Asheville, NC, 1983

DBR Gallery, Cleveland, OH, 1983
Hodges/Taylor Gallery, Charlotte, NC, 1983
Oxford Gallery, Oxford, England, 1982
Southeastern Center For Contemporary Art, Winston-Salem, NC, 1981
Impressions Gallery, Boston, MA, 1981
Phyllis Weil Gallery, New York, NY, 1981
Van Straaten Gallery, Chicago, IL, 1977
Impressions Gallery, Boston, MA, 1975

GROUP EXHIBITIONS (selected)

Antidote, Claire Oliver Gallery, New York, NY, 2010
20th Anniversary Exhibition, Christa Faut Gallery, Charlotte, NC, 2009
Peace Tower, Whitney Biennial, New York, NY, 2006
The Elements, Louise Wells Cameron Museum of Art, Wilmington, NC, 2005
X-posed, Somerhill Gallery, Chapel Hill, NC, 2005
Material Matters, Community Gallery, Opera House, Earlville, NY, 2004
15x15, Christa Faut Gallery, Cornelius, NC, 2003
Mercury Art Works, Athens, GA, 2002
A Good Look, Thomas McCormick Gallery, Chicago, IL, 2002
Twelve Over Six, Greenville Museum of Art, Greenville, NC, 2001
Vanessa Suchar Fine Art, London, England, 2000
20th Century North Carolina Masters, Lee Hansley Gallery, Raleigh, NC, 2000
Museo Del Vidrio, Monterrey, Mexico, 1999
Vitreographs, Memorial Art Gallery, University of Rochester, Rochester, NY, 1998
Abstracting the Elements of Art, Utah Museum of Fine Arts, Salt Lake City, UT, 1998
Pinned to the Wall, Parchman Stremmel Gallery, San Antonio, TX, 1997
Taylor-Jenson Fine Arts, Palmerston North, New Zealand, 1997
Portland Art Museum, Portland, OR, 1997
Celebrating Southern Art, Morris Museum of Art, Augusta, GA, 1997
Come Shining, Poets' Theater, New York, NY, 1997
Shanxia Government Art Gallery, Xian, China, 1996
Transparent Motives, New Orleans Museum of Art, LA, 1995
Luminous Impressions, The Kala Institute, Berkeley, CA, 1994
Artists Who Teach, J. Rosenthal Gallery, Chicago, IL, 1992
East Tennessee Collects, Knoxville Museum of Art, Knoxville, TN, 1991
Art of Color, Samuel P. Harn Museum of Art, Gainesville, FL, 1990
Painting Beyond The Death of Painting, Kuznetsky Most Exhibition Hall, Moscow, Soviet Union, 1989
Lorenzelli Arte, Milan, Italy, 1989

Luminous Impressions, Mint Museum of Art, Charlotte, NC, 1987
Southern Abstraction, Raleigh City Gallery, Raleigh, NC, 1987
Tenth Anniversary, Secca Seven, Southeastern Center for Contemporary Art, Winston-Salem, NC, 1987
Drawings, Knight Gallery, Spirit Square Art Center, Charlotte, NC, 1985
Layering—An Art of Time and Space, Albuquerque Museum of Art, Albuquerque, NM, 1985
North Carolina Visual Arts Award Exhibition, SECCA, Winston-Salem, NC, 1985
A Portrait of the South, Palazzo Venezia, Rome, Italy, 1984
Experimental Drawing, Schwayer Art Gallery, University of Denver, Denver, CO, 1984
On The Leading Edge—Cross Currents In Contemporary Art, General Electric Headquarters, Fairfield, CT, 1983
SECCA Southeastern Seven VI, Southeastern Center for Contemporary Art, Winston-Salem, NC, 1983
Transpersonal Images, VIII International Conference, Transpersonal Association, Davos, Switzerland, 1983
Paintings of the '70s, World's Fair, Knoxville, TN, 1982
Serial Imagery, Huntsville Museum of Art, Huntsville, AL, 1982
Childe Hassam Purchase Fund Exhibition, American Academy and Institute of Arts and Letters, New York, NY, 1981, 1987
Abstract Art on Paper, Impressions Gallery, Boston, MA, 1980
XV International São Paulo Bienal, São Paulo, Brazil, 1979
6th British International Print Biennale, Bradford, England, 1979
100 New Acquisitions, The Brooklyn Museum, Brooklyn, NY, 1978
USIA Touring Exhibition, Japan, 1977
35 Artists of the Southeast, The High Museum of Art, Atlanta, GA, 1976

FELLOWSHIPS

Boswell Family Fellowship, 2007
NEA/SAF Fellowship, 1986
North Carolina Visual Arts Fellowship, 1984
SECCA Southeastern Seven Fellowship, 1981

PUBLIC COLLECTIONS

Achenbach Foundation, San Francisco, CA
Albuquerque Museum of Art, Albuquerque, NM
Art Bank Collection, U.S. Department of State, Washington, DC
Asheville Museum of Art, Asheville, NC
Babson Institute, Wellesley Hills, MA
Baltimore Museum of Art, Baltimore, MD

Beloit College, Beloit, WI
Boise Gallery of Art, Boise, ID
Boston Public Library, Boston, MA
Bowdoin College, Brunswick, ME
British Museum, London, England
Brooklyn Museum, Brooklyn, NY
California State College, Fullerton, CA
California State University, Chico, CA
Carroll Reece Museum, Johnson City, TN
Cheekwood Fine Arts Center, Nashville, TN
Chicago Art Institute, Chicago, IL
Cleveland Museum of Art, Cleveland, OH
Columbus Museum of Art, Columbus, GA
Davidson College, Davidson, NC
Dayton Art Institute, Dayton, OH
Drake University, Des Moines, IA
Drury College, Springfield, MO
E. B. Crocker Art Gallery, Sacramento, CA
Eckerd College, St. Petersburg, FL
Fayetteville Museum of Art, Fayetteville, NC
Florida State University, Tallahassee, FL
Foundation for the Carolinas, Charlotte, NC
Goddard Center for the Visual Arts, Ardmore, OK
Greenville County Museum of Art, Greenville, SC
Gulbenkian Museum, Lisbon, Portugal
Hickory Museum of Art, Hickory, NC
High Museum of Art, Atlanta, GA
Honolulu Academy of Arts, Honolulu, HI
Huntsville Museum of Art, Huntsville, AL
Indianapolis Museum of Art, IN
Indiana State University, Evansville, IN
Kalamazoo Institute of Art, Kalamazoo, MI
Knoxville Museum of Art, Knoxville, TN
Kohler Art Center, Sheboygan, WI
Lafayette College, Skillman Library, Easton, PA
Library of Congress, Washington, DC
Louise Wells Cameron Museum of Art, Wilmington, NC
Madison Arts Center, Madison, WI
Manhattan College, Riverdale, NY
Mesa Community College, Mesa, AZ
Michigan State University, East Lansing, MI
Minneapolis Institute of Art, Minneapolis, MN
Minnesota Museum of Art, St Paul, MN
Mint Museum of Art, Charlotte, NC
Morris Museum of Art, Augusta, GA
Museum of Fine Arts, Boston, MA
Museum of Fine Arts, Springfield, MA
Muskegon Art Museum, Muskegon, MI
Nasson College, Springvale, ME
National Academy of Sciences, Washington, DC
Newark Public Library, Newark, NJ
New York Public Library, New York, NY
North Carolina Museum of Art, Raleigh, NC
North Carolina School of Law, Chapel Hill, NC
North Dakota State University, Fargo, ND
Northern Arizona University, Flagstaff, AZ
Northern Illinois University, Dekalb, IL

Northwood Institute, Dallas, TX
Norton Gallery of Art, West Palm Beach, FL
Ogden Museum of Southern Art, New Orleans, LA
Pennsylvania State University, State College, PA
Philadelphia Museum of Art, Philadelphia, PA
Portland Museum of Art, Portland, OR
Ringling Museum, Sarasota, FL
Rockford College, Rockford, IL
Rutgers University, New Brunswick, NJ
St. Lawrence University, Canton, NY
Samuel P. Harn Museum, Gainesville, FL
San Jose State College, San Jose, CA
Skidmore College, Saratoga Springs, NY
Smith College, Northampton, MA
Smithsonian Institution, Washington, DC
Southern Illinois University, Edwardsville, IL
Southern Utah State College, Cedar City, UT
Springfield Art Museum, Springfield, MO
Stetson University, Deland, FL
Syracuse University, Syracuse, NY
United States Information Agency, Japan
University of California, Los Angeles, CA
University of California, Riverside, CA
University of Georgia, Athens, GA
University of Iowa, Iowa City, IA
University of Maine, Orono, ME
University of Missouri, Columbia, MO
University of Nebraska, Lincoln, NE
University of Nevada, Reno, NV
University of North Carolina, Chapel Hill, NC
University of Oklahoma, Norman, OK
University of South Dakota, Vermillion, SD
University of Virginia, Charlottesville, VA
University of West Virginia, Morgantown, WV
University of Wisconsin, Sheboygan, WI
Utah Museum, Salt Lake City, UT
Victoria and Albert Museum, London, England
Western Carolina University, Cullowhee, NC
Westminster College, New Wilmington, PA
Whitney Museum of Art, New York, NY
Wittenberg University, Springfield, OH

AWARDS

ASC Award, 2008
Hunter-Hamilton Love of Teaching Award, 2003
The North Carolina Award, 1999

ACKNOWLEDGMENTS

Among his many honors, Herb Jackson holds the distinguished title of the Douglas C. Houchens Professor of Art at Davidson College. For forty-two years, he has taught his painting students by his own example. This book and the exhibition that inspired it not only celebrate Herb's dedicated service to Davidson College and the greater cultural community but also his fifty-year career as a professional artist.

Herb's insights and assistance throughout the development of this project have been invaluable. He graciously made available all the works in his archive for use. During the summer and early fall of 2010, I made several trips to his studio to study various works and collaborate with him on layouts for both the exhibition and book. Herb's organization and affability made for a most pleasurable and memorable experience. I hope that viewers and readers alike will sense and be swept up in that spirit.

Herb's daily practice of putting paint on canvas is his stock in trade. He has remarked over the years that his ongoing collaboration with Mark Golden and the research and development staff at Golden Artist Colors, Inc., has enabled him to achieve the vibrant colors, rich textures, and incomparable luminosity that have become the hallmarks of his signature style. In honor of Herb's golden anniversary, Golden Artist Colors, Inc., has generously underwritten the production of this book. We anticipate many more years of mutually beneficial developments from Golden's partnership with Herb.

Roger Manley, Herb's former student and current director of the Gregg Museum of Art & Design at North Carolina State University, has provided an essay—better, a memoir—that evokes the profound

influence that Herb had on him during his formative years at Davidson. Herb's dedication to teaching and painting served as the catalyst for Roger's career as an award-winning photographer, author, curator, filmmaker, and folklorist. Just think of the cultural void there would be without his epic documentary *Mana: Beyond Belief* or his many acclaimed exhibitions, such as *The End Is Near!: Visions of Apocalypse, Millennium, and Utopia*. Were it not for Herb's career intervention, Roger might have stuck to his boyhood dream of becoming a scientist and now be sporting a Nobel Prize medal between the lapels of his "Harris Tweed jacket with professorial elbow patches."

We are grateful to Herb's collectors for generously offering to loan works for the exhibition. They include Rick and Dana Martin Davis, Jay Everette, and Christa and Bob Faut. Each of these patrons—and friends—agreed, without hesitation, to our request for their respective *Veronica's Veils* paintings in order to complete the installation devoted to this ongoing series. Our thanks also to Herb's primary representative, Claire Oliver of Claire Oliver Gallery, New York, for her support and enthusiasm.

For their assistance in organizing the exhibition and publication, we are indebted to our gallery interns—Courtney Melvin, Charlotte Michaud, Molly Verlin, and Ally Weihe. Austin Sheppard and Max Heller oversaw the careful transportation and installation of works. And for her support in all aspects of operations here at the Van Every/Smith Galleries, I especially wish to thank assistant curator Tara Clayton '08.

We have only the highest praise for John Brooks Gray for his elegant book design. David Ramsey provided photography of the paintings and the details that grace the book's cover as well as its pages. We are indebted to Chris Reynolds, Terri Smith, and the staff at Belk Printing Technologies for producing an exceptional printed piece that captures all the depth and brilliance of Herb's work. Once again, Gerald Zeigerman edited the texts to ensure we maintained continuity and clarity throughout. He didn't even make us clutch our pearls once.

The talented faculty and staff at Davidson College continue to offer their support for our exhibitions and publications. We also appreciate the encouragement of John W. Kuykendal '59, interim president; Clark Ross, dean of faculty; Cort Savage, professor of art and art department chair; the esteemed faculty of the art department; Eileen Keeley '89, vice president of college relations; and Stephanie Glaser '92, director of major gifts.

Last—yet of equal importance—this publication is dedicated to Davidson's outstanding faculty, staff, and students—past and present.

bt